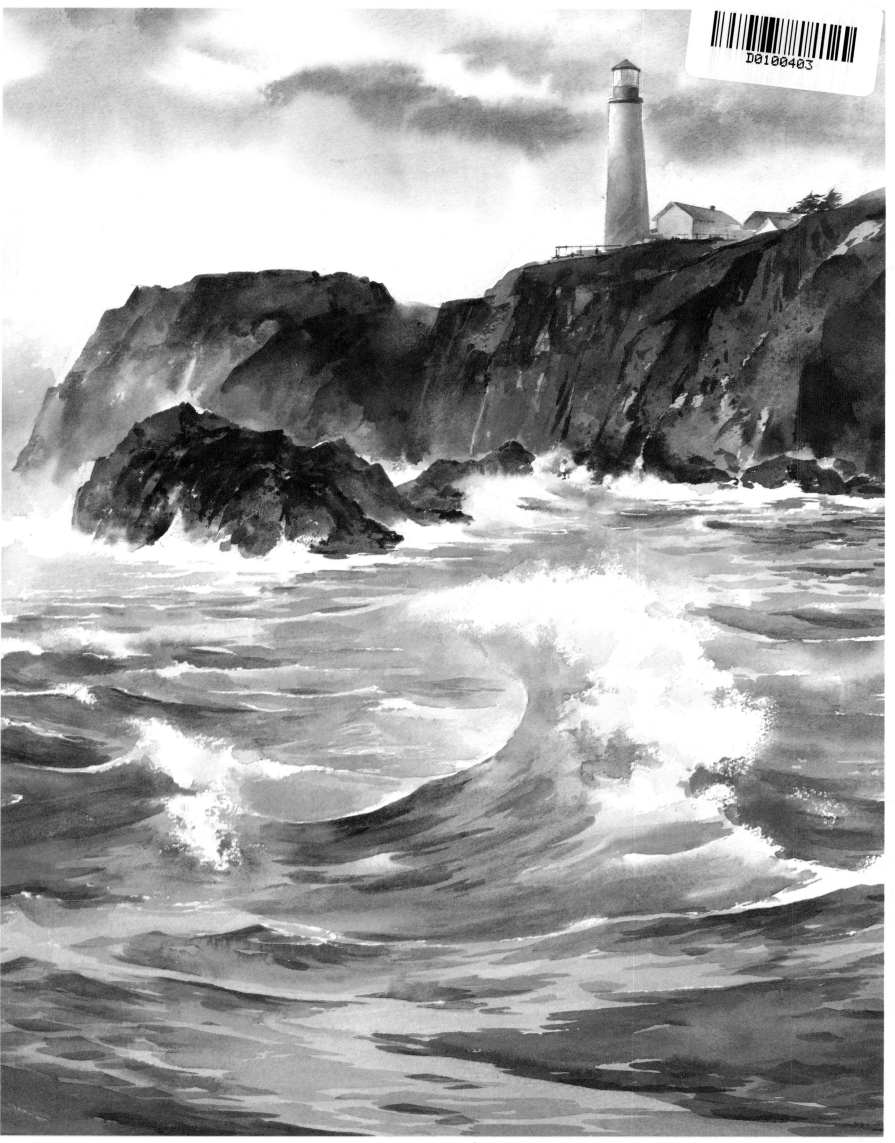

"New England Cove" Watercolor 18" x 25"

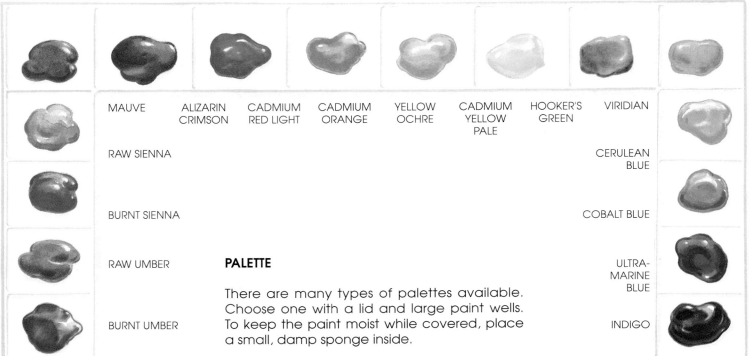

		MAUVE	ALIZARIN CRIMSON	CADMIUM RED LIGHT	CADMIUM ORANGE	YELLOW OCHRE	CADMIUM YELLOW PALE	HOOKER'S GREEN	VIRIDIAN	

RAW SIENNA

CERULEAN BLUE

BURNT SIENNA

COBALT BLUE

PALETTE

RAW UMBER

ULTRA-MARINE BLUE

There are many types of palettes available. Choose one with a lid and large paint wells. To keep the paint moist while covered, place a small, damp sponge inside.

BURNT UMBER

INDIGO

SUPPLIES

CLOTH PAINT RAG

WATERCOLOR PAINT TUBE

SPONGE

WATER CONTAINER

PAPER TOWELS

SPRAY BOTTLE

ELECTRIC HAIR DRYER

BRUSHES

Buy the best watercolor brushes you can afford. You will need a 2″ flat (it should be flat and straight when wet), #30, #10 and #6 rounds (these should make a good point when wet), a #4 rigger, and a 3″ or 4″ flat.

PAPER

The best paper has a rag content and is acid-free. I use 300 lb. rough watercolor paper or cold-press illustration board. NOTE — Watercolor paper creates much of its own texture because it is rough. Illustration board is smoother, so textures are created with techniques such as blotting, scraping, spattering and spraying.

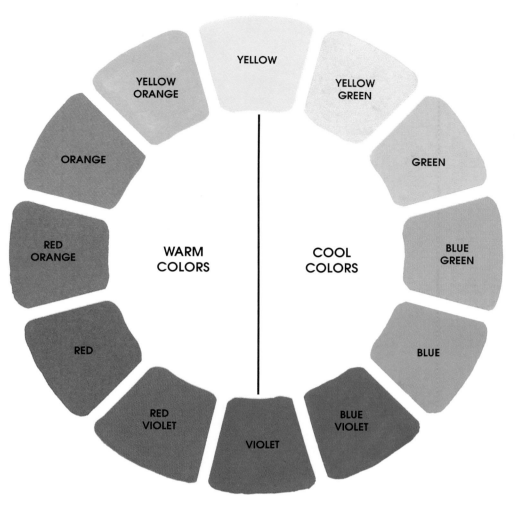

COLOR WHEEL

- YELLOW
- YELLOW ORANGE
- ORANGE
- RED ORANGE
- RED
- RED VIOLET
- VIOLET
- BLUE VIOLET
- BLUE
- BLUE GREEN
- GREEN
- YELLOW GREEN

WARM COLORS

COOL COLORS

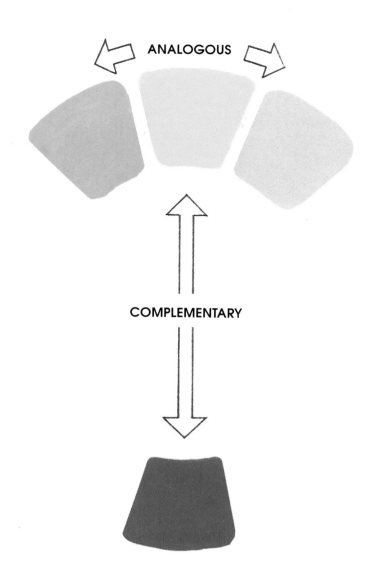

ANALOGOUS

COMPLEMENTARY

* COLORS THAT RELATE

MIXING COMPLEMENTS

COLOR

A basic color wheel starts with the primary colors of red, yellow and blue. Secondary colors of orange, green and violet are formed from the primary colors.

*Colors are said to relate when they have something in common such as intensity or value (see example left).

Hue — The color wheel above contains twelve strong hues. Half the wheel is warm, and half is cool. Warm colors tend to advance and cool colors tend to recede.

Analogous Colors — Analogous colors are any three colors that are adjacent on the color wheel.

Complementary Colors — Complementary colors are any two colors directly across from each other on the color wheel. One will be warm and the other will be cool. Note — When complementary colors are mixed together they gray one another (see example left).

Intensity — The transition of a color from weak (grayed) to strong (pure). Note — Strong, intense and warm colors advance; cool, weak, and gray colors recede.

Value — The relative lightness or darkness of a hue. Value gives a sense of depth in a painting. Darks recede, lights advance.

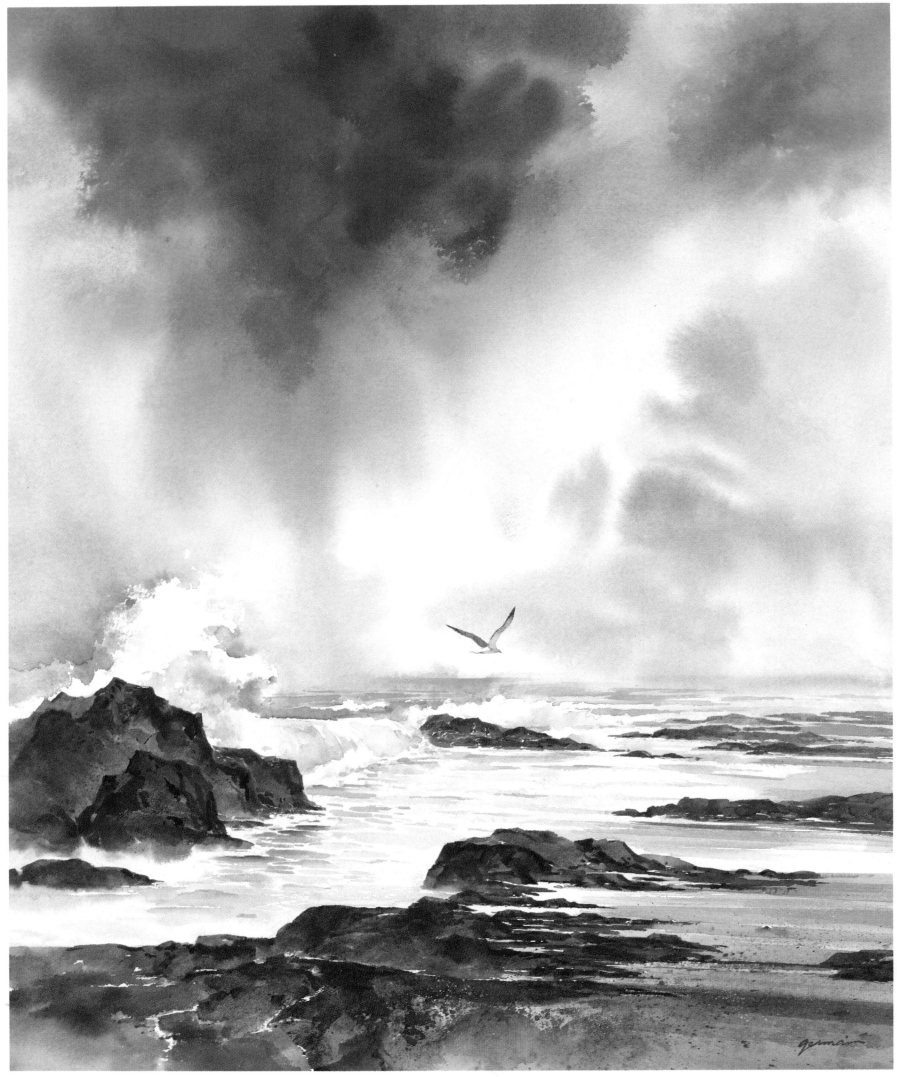

"White Water" Watercolor 18" x 25"

This is a typical California coastline with rocks, pounding surf, spray, tide pools, and an overcast sky. These elements create a moody atmosphere full of contrasts that is well-suited to the use of transparent watercolor (where the whites are the paper). The light colors are mostly water with very little pigment. The darks have less water and more pigment.

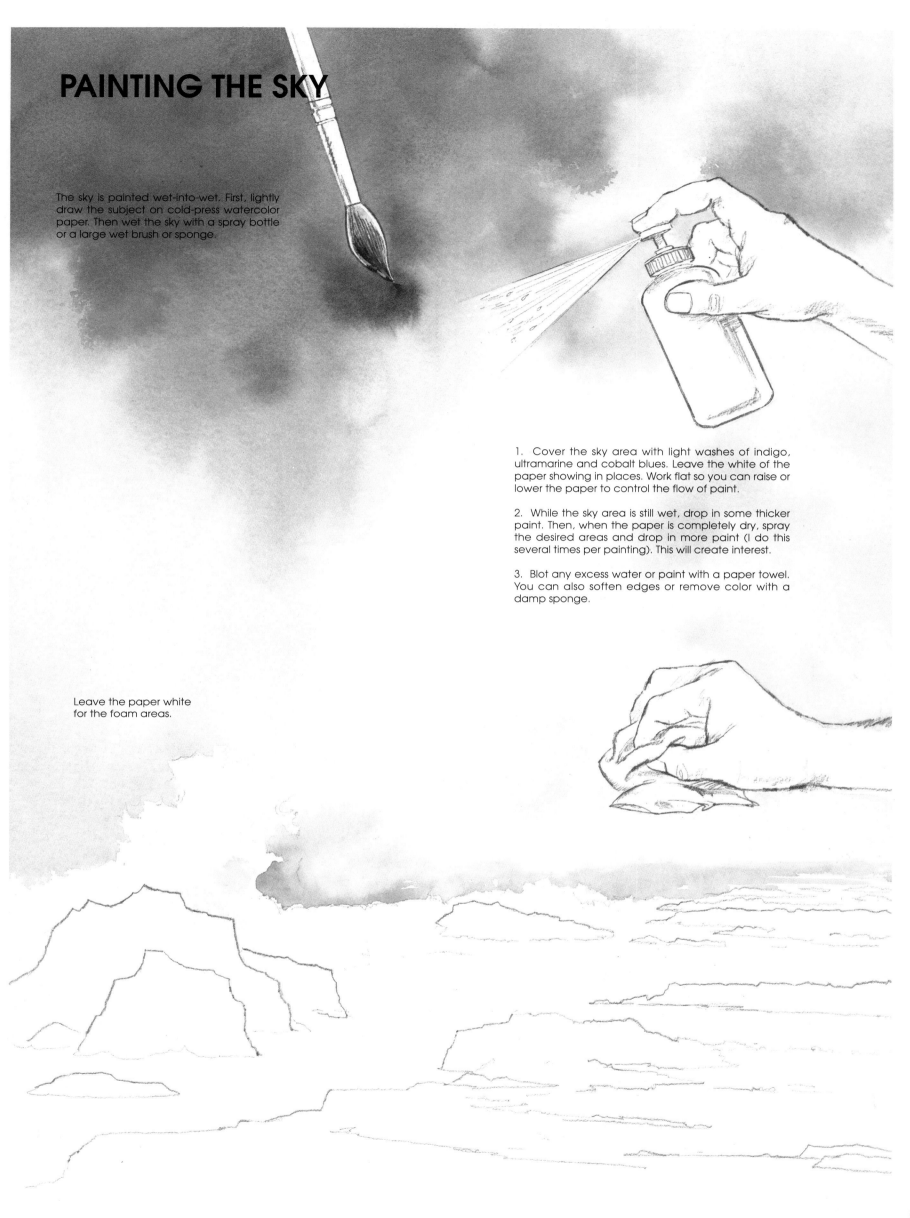

PAINTING THE SKY

The sky is painted wet-into-wet. First, lightly draw the subject on cold-press watercolor paper. Then wet the sky with a spray bottle or a large wet brush or sponge.

1. Cover the sky area with light washes of indigo, ultramarine and cobalt blues. Leave the white of the paper showing in places. Work flat so you can raise or lower the paper to control the flow of paint.

2. While the sky area is still wet, drop in some thicker paint. Then, when the paper is completely dry, spray the desired areas and drop in more paint (I do this several times per painting). This will create interest.

3. Blot any excess water or paint with a paper towel. You can also soften edges or remove color with a damp sponge.

Leave the paper white for the foam areas.

PAINTING ROCKS

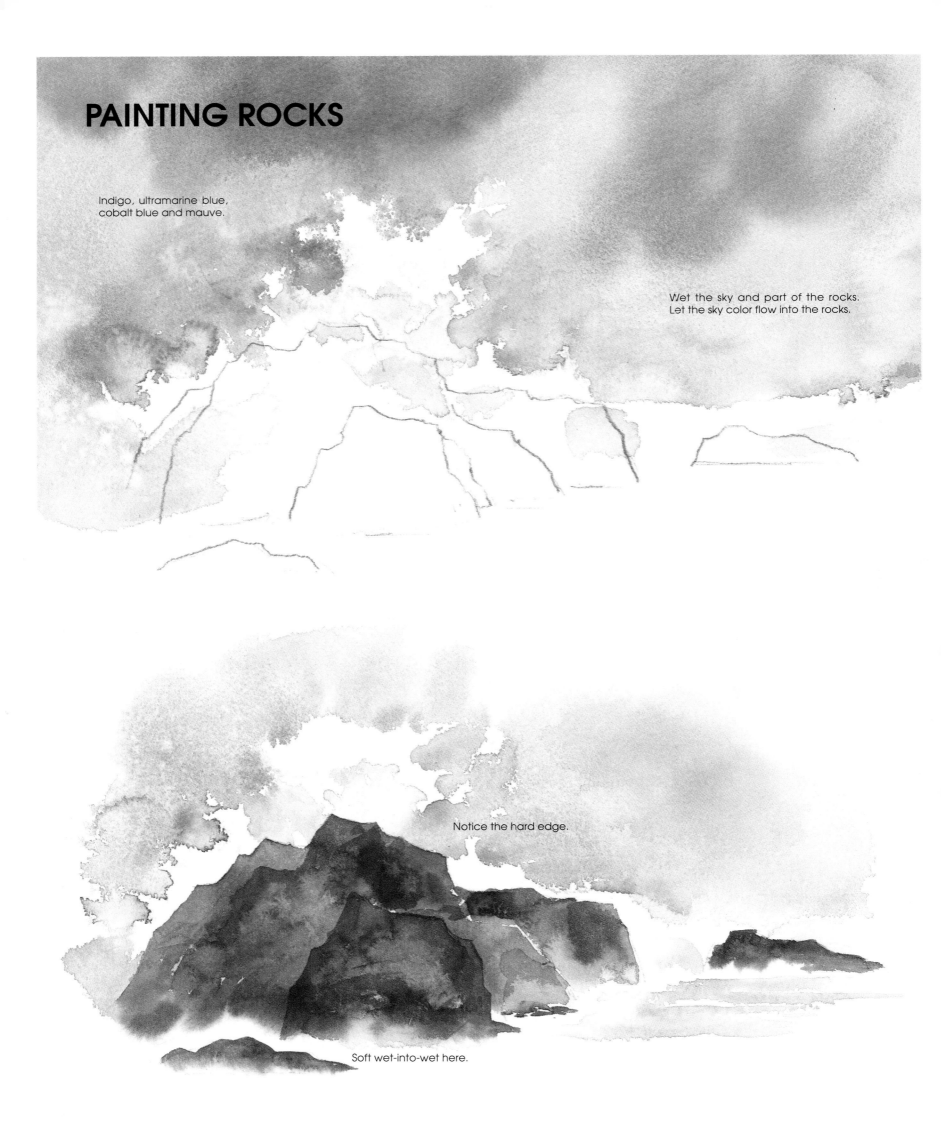

Indigo, ultramarine blue,
cobalt blue and mauve.

Wet the sky and part of the rocks.
Let the sky color flow into the rocks.

Notice the hard edge.

Soft wet-into-wet here.

Paint the basic shape of the rock, varying the colors and the lights and the darks. Consider the nature of the rocks. They are hard with sharp edges — NOT "DOUGHY". They have a variety of shapes within the total shape. They have textures. They have contrasts of light and dark, especially when wet.

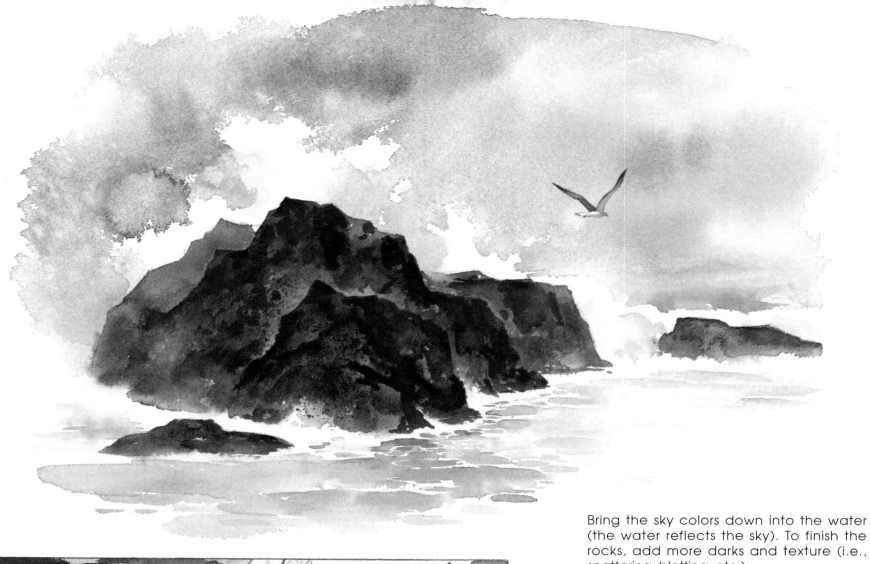

Bring the sky colors down into the water (the water reflects the sky). To finish the rocks, add more darks and texture (i.e., spattering, blotting, etc.).

Lastly, draw the sea gull on tracing paper and move it around the painting until it looks right. Transfer it to the board and paint it.

PAINTING SAND

Painting wet-into-wet, use raw umber, burnt umber, mauve, and ultramarine blue to build up the sand and the shadows. While still wet, stroke horizontally with a totally clean, dry brush until the sand looks flat. Note — the dry brush should move pigment around, it should not add or take pigment away. Lastly, spatter in the sand texture (cover the rest of the painting with a cloth to protect it).

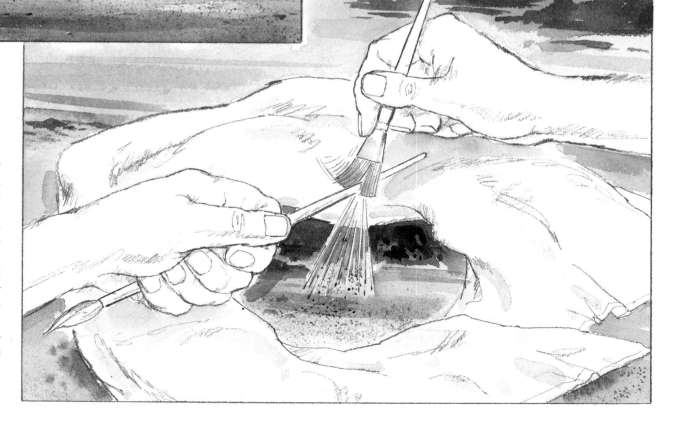

WAVE ACTION

Waves cannot really be planned, so it is not necessary to make a drawing. Be aware of the "happy accident" — when something unexpectedly good happens, leave it alone! When it happens, as it often does in watercolor painting, work with it — develop it!

Here a "happy accident" was developed into a white cap. Notice the strong contrasts on the wind blown waves topped with foam and spray. Also, be aware of the variety of shapes within the wave.

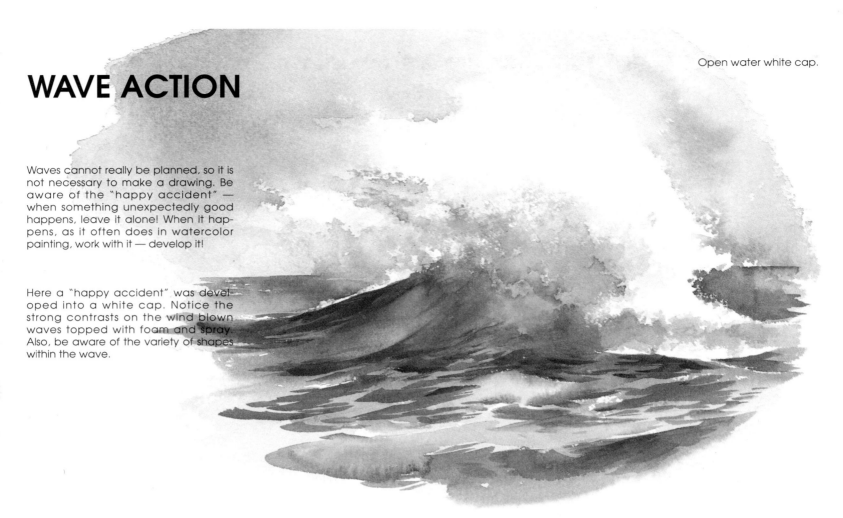

Open water white cap.

BREAKING WAVES

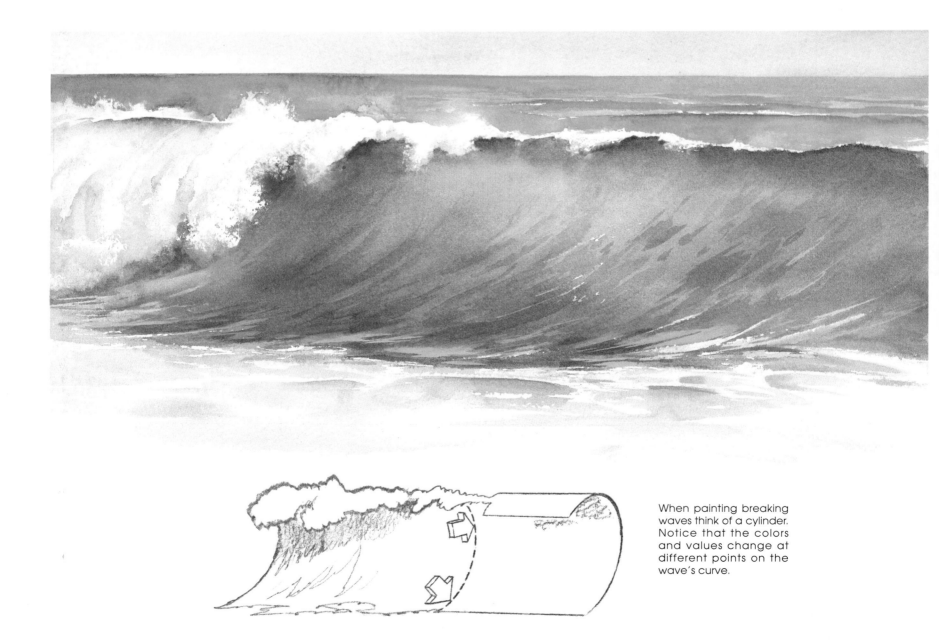

When painting breaking waves think of a cylinder. Notice that the colors and values change at different points on the wave's curve.

SEA AND SAND

Make a light sketch, then apply cerulean blue in the sky and the water. Use indigo and mauve for the cloud shadows. For the sand, stroke raw sienna into the water, wet-into-wet. Any dark value works well for trees and rocks. Experiment!

Waves often break before they reach the beach and the water flows in a flat, wide expanse onto the sand. The sand shows through the water because it is so shallow here. In the finished painting below, the mood is calm and serene.

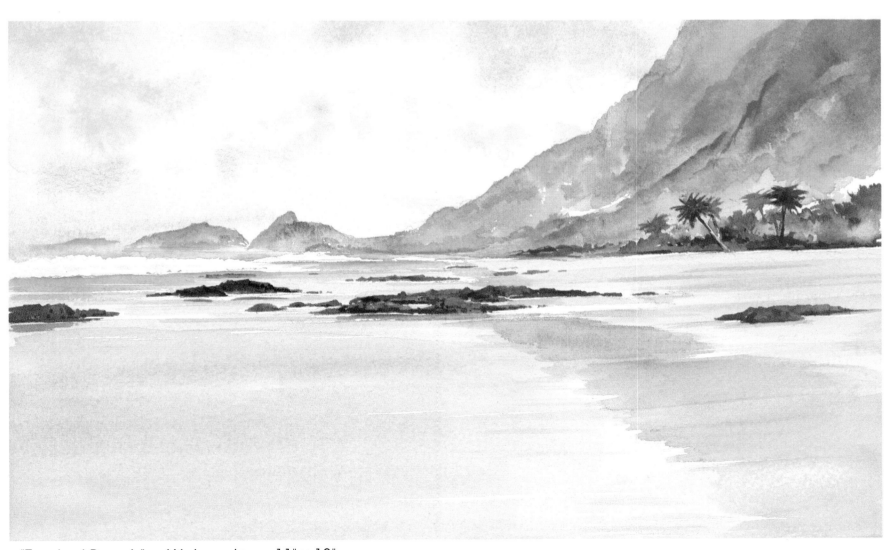

"Tropical Beach" Watercolor 11" x 18"

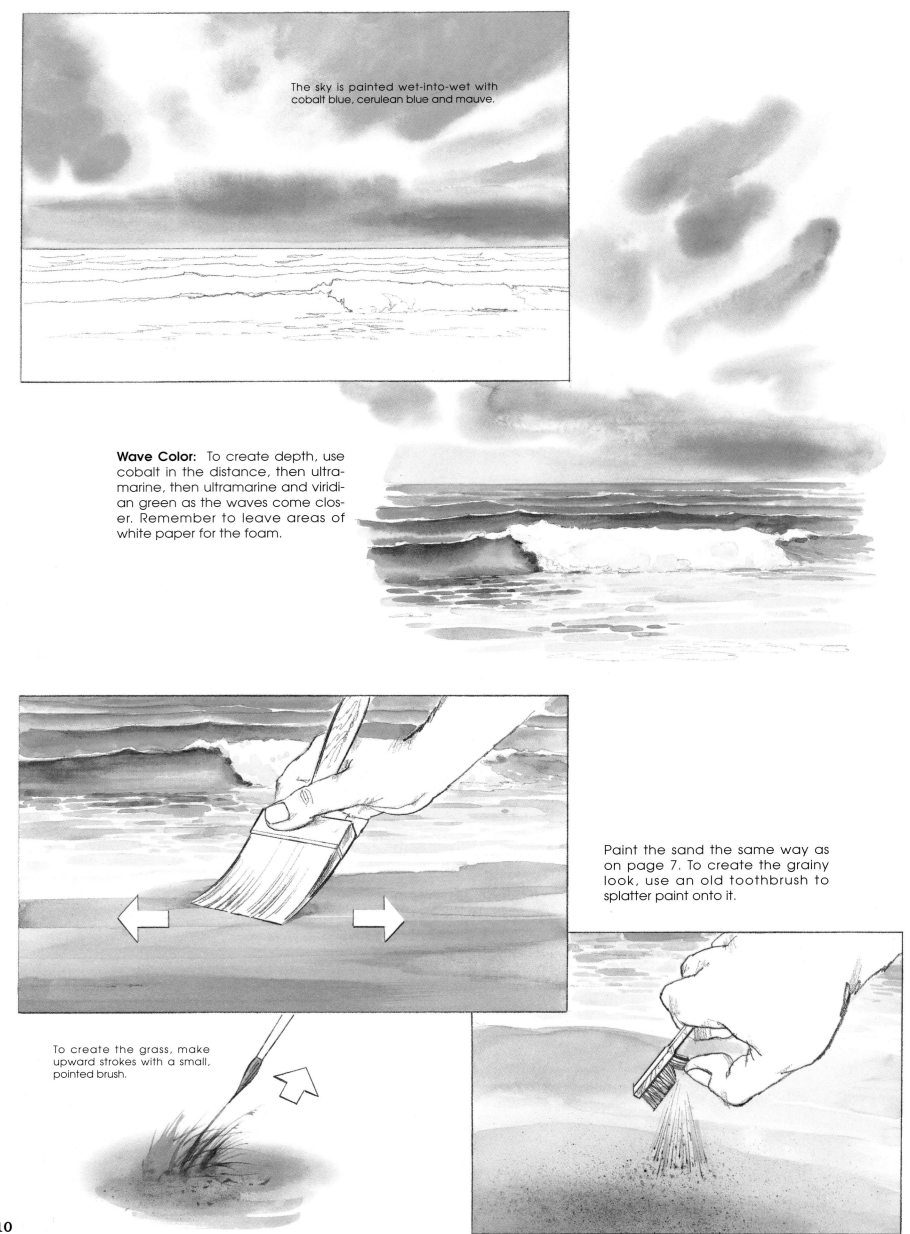

The sky is painted wet-into-wet with cobalt blue, cerulean blue and mauve.

Wave Color: To create depth, use cobalt in the distance, then ultramarine, then ultramarine and viridian green as the waves come closer. Remember to leave areas of white paper for the foam.

Paint the sand the same way as on page 7. To create the grainy look, use an old toothbrush to splatter paint onto it.

To create the grass, make upward strokes with a small, pointed brush.

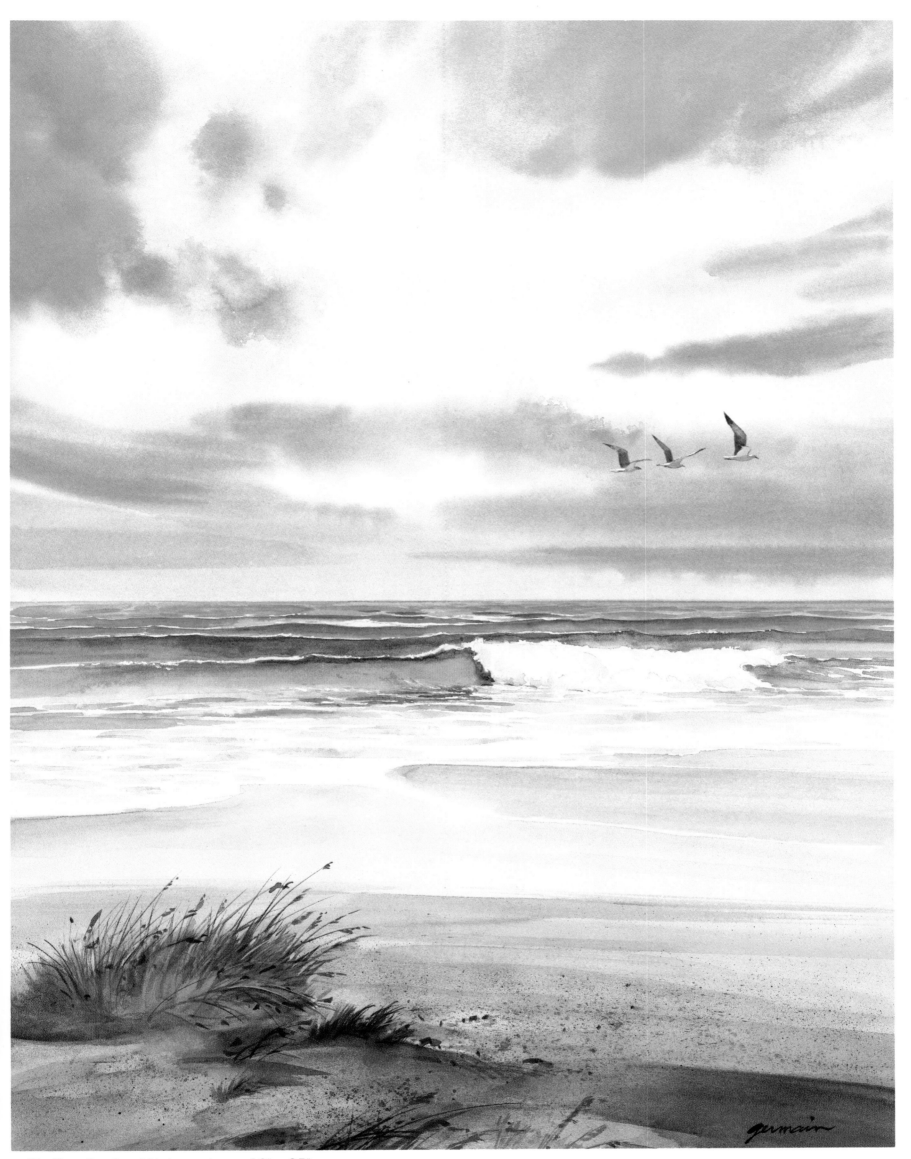

"Rolling Surf" Watercolor 18" x 25"

11

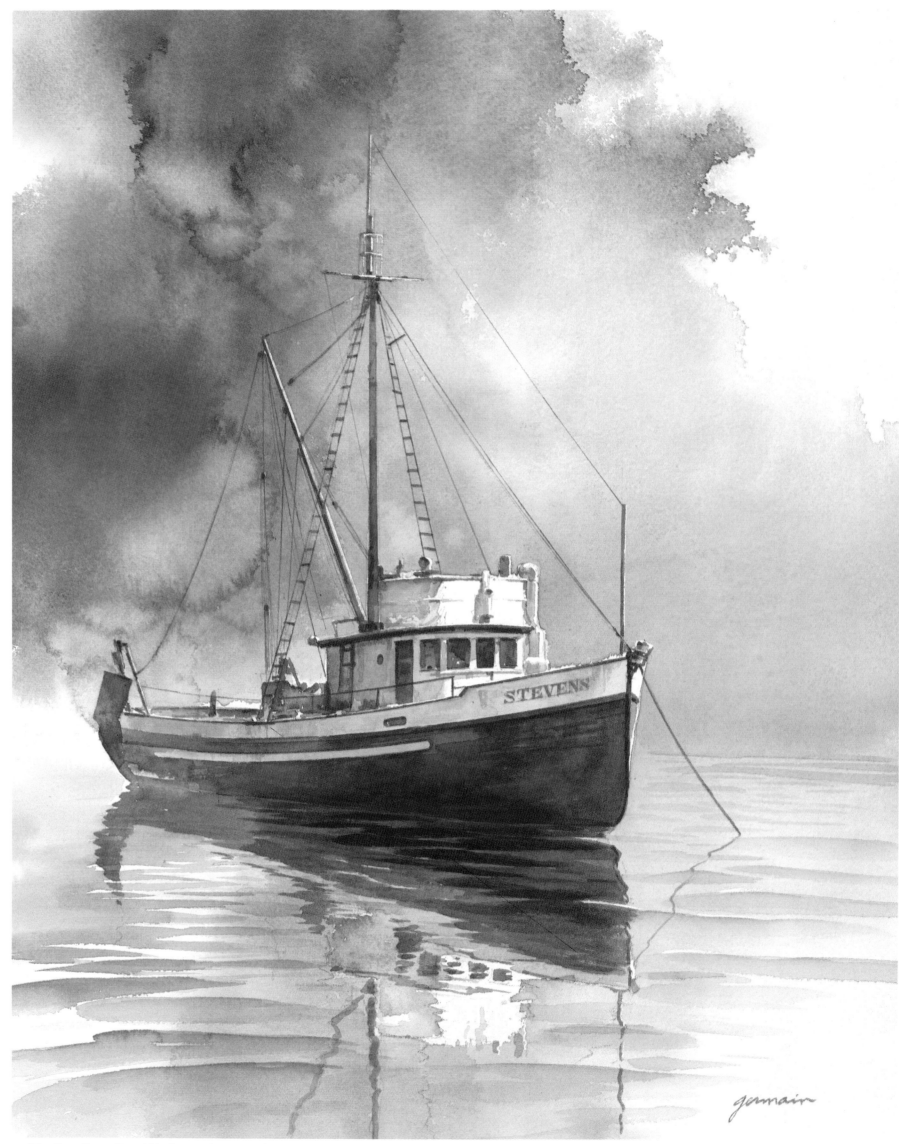

"Reflections" Watercolor 18" x 25"

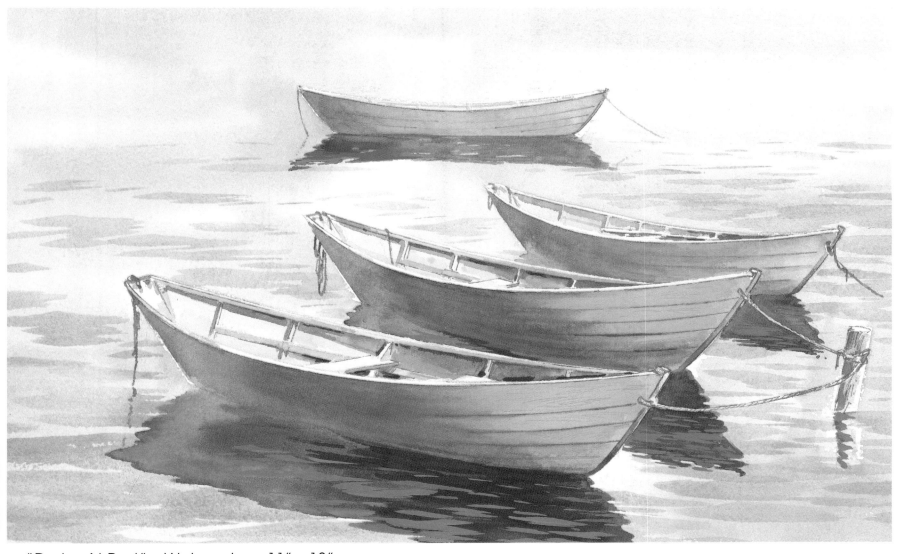

"Dories At Rest" Watercolor 11" x 18"

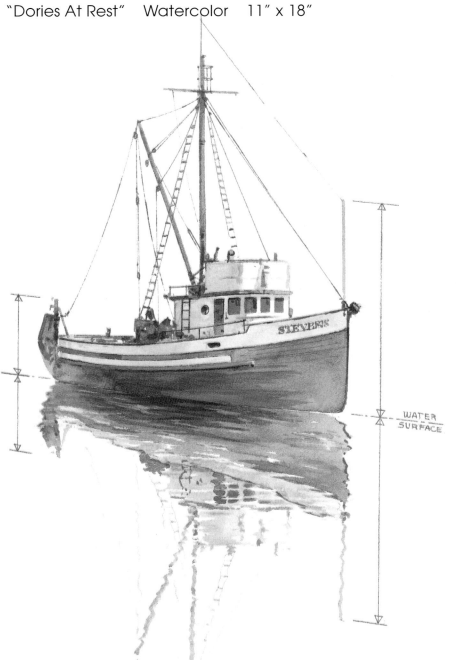

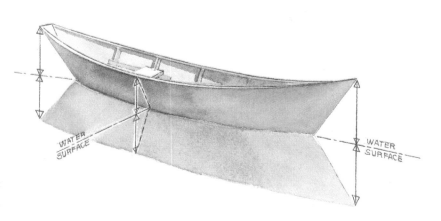

REFLECTIONS

Objects reflect straight down from the water surface (or plane) the same distance as the object is above the water surface (see examples on pages 12, 13, and 14).

Water is like a mirror. The reflection has the same vanishing point as the object. Water also reflects the sky color. This is true when the water surface is calm or glassy. Wave action causes the reflections to lengthen because of the tilt of the surface. Very choppy, rough water shows little or no reflection.

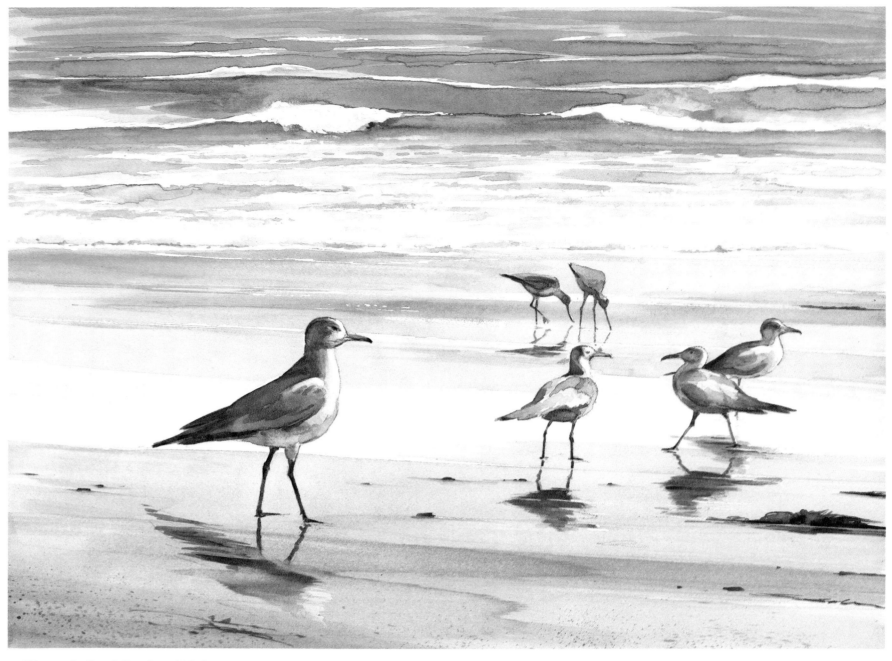

"Beach Buddies" Watercolor 11" x 14"

Study the water reflections of these sea birds in wet sand. Even a film of water over sand reflects. Consider the surface plane as a mirror, but water streaks on the sand will affect the reflections, as shown here.

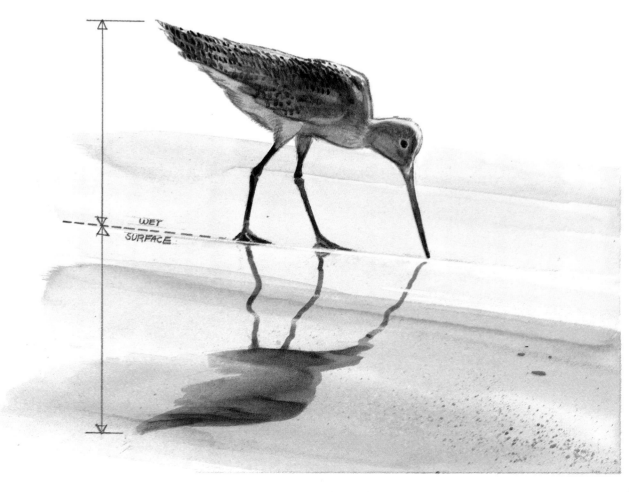

WET
SURFACE

Any part of the bird above the water surface is reflected the same distance in a straight line below the water surface (or plane). Note — birds in flight reflect the same way: from the bird in the air to the surface plane and down the same distance below the plane.

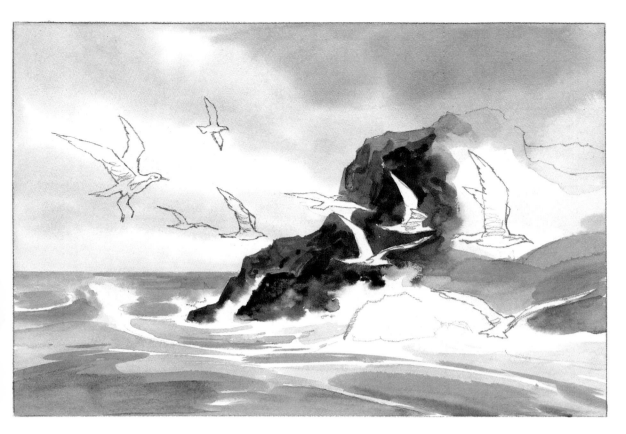

PAINTING BIRDS

You can paint the background around the birds or you can mask them out with liquid or paper frisket first. Both methods are shown here.

Use more than one color on the birds. To create interest, paint light against dark and vice versa, as shown here. This painting was done on cold-pressed illustration board.

The sky is painted wet-into-wet with cobalt and indigo. Some edges are hard; others are soft. The rocks are mostly indigo. Use blotting and spattering techniques to create texture. The water is cobalt, ultramarine, viridian and a touch of indigo.

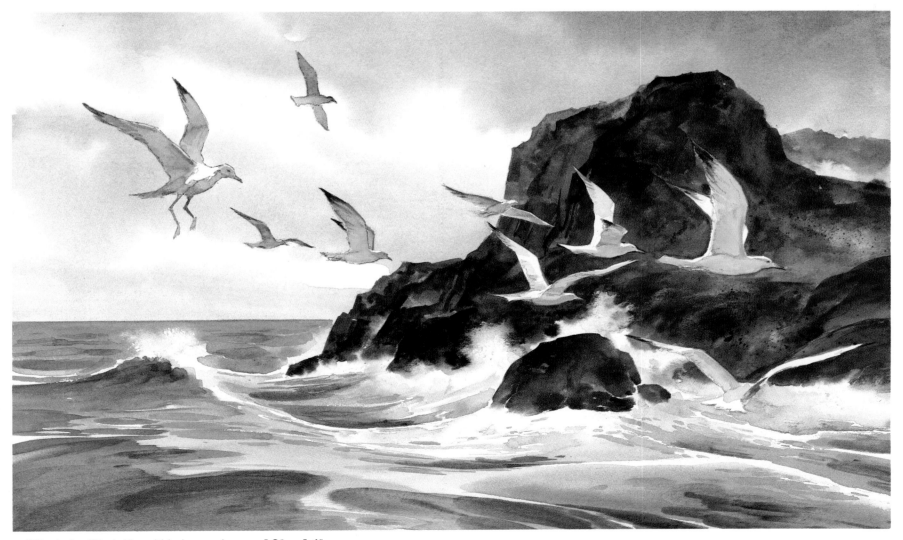

"Birds In Flight" Watercolor 10" x 14"

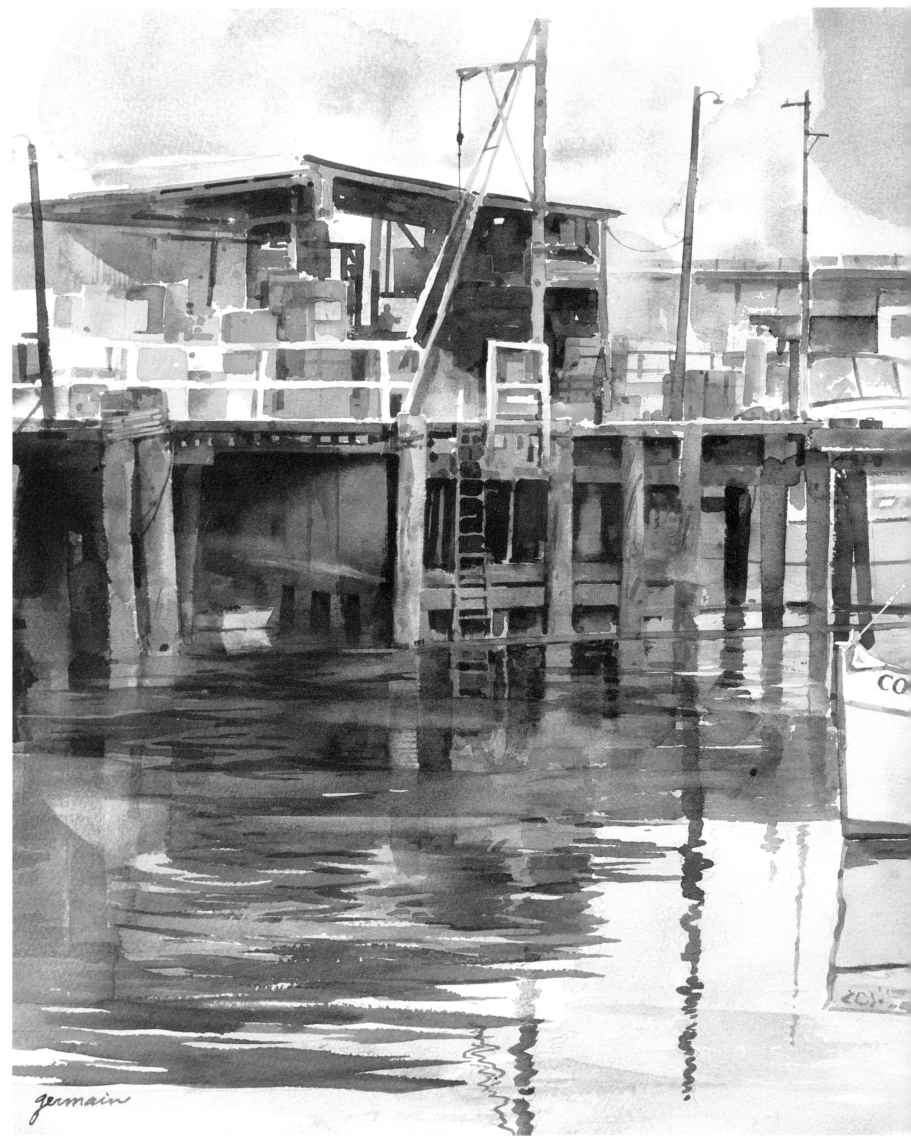

germain

"Sausalito" Watercolor 17" x 21"

This Sausalito Harbor scene demonstrates much of what we have learned about reflections. I have tried to create the impression of a colorful and crowded harbor. It may appear complicated, but I have broken it down into a series of basic shapes below.

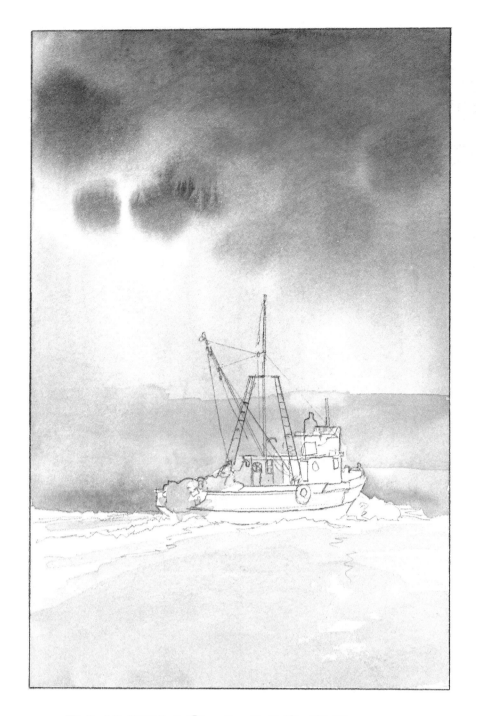

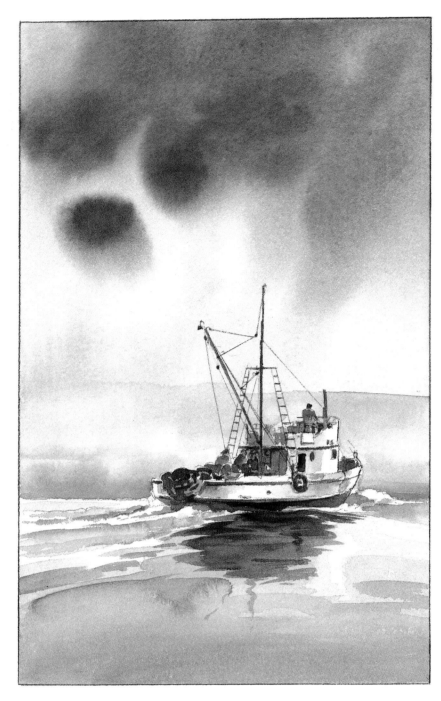

PAINTING A MOOD

The mood created here is of a foggy, cool day with muted colors, close values and few details. Ultramarine, mauve and cobalt are used for both the sky and the water. Mauve is the dominant color. Notice that no horizon line is visible. Interest is created by the detail on the boat which has the only warm colors (in small amounts).

Using a straight edge.

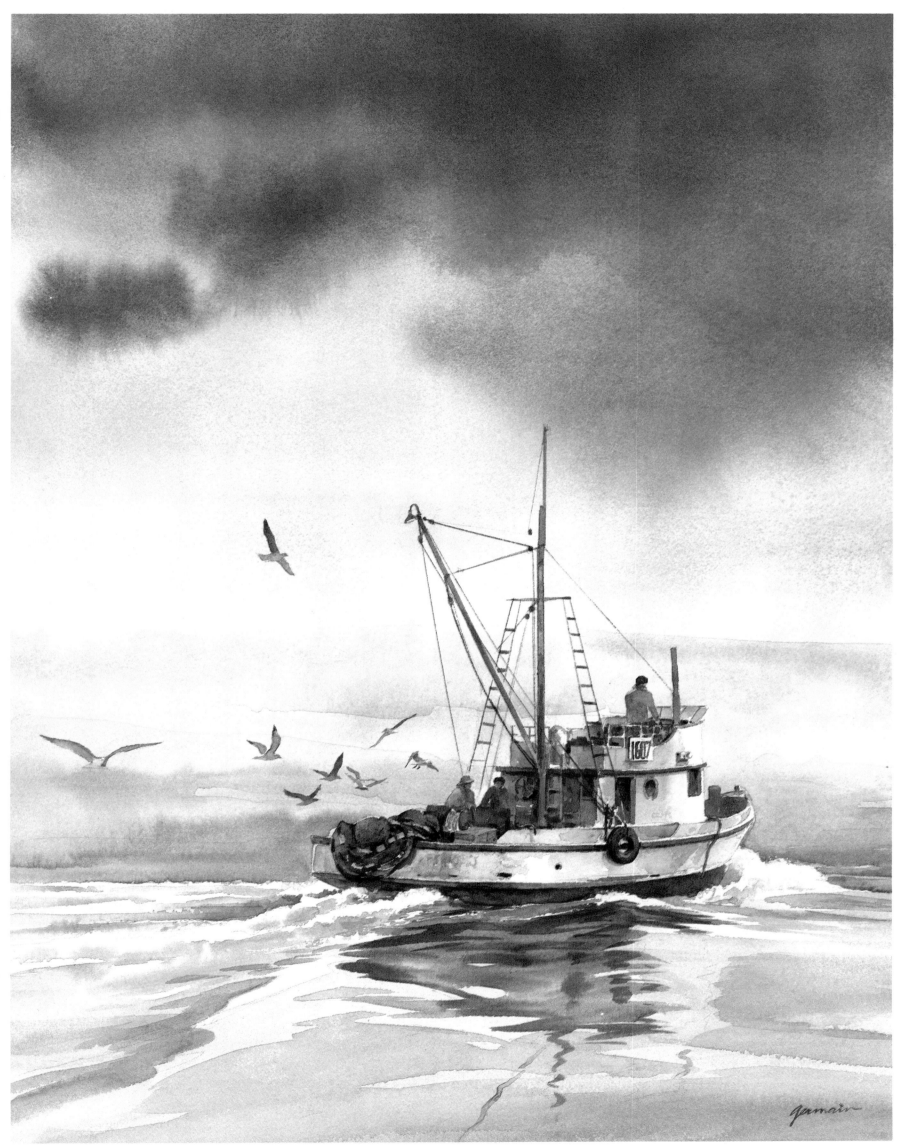

"Heading Out To Sea" Watercolor 18" x 25"

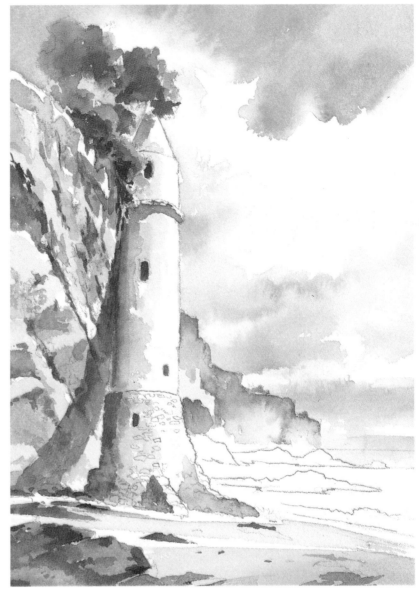

The same colors are used in the cliff and in the tower base, but they differ in size and technique. The cliffs are painted loosely and the stones of the tower are a variety of sizes, colors and shapes. Use natural colors; you can mix a multitude of colors from these.

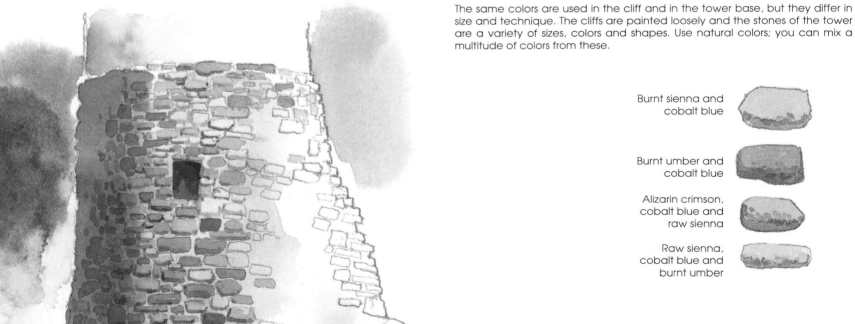

Burnt sienna and
cobalt blue

Burnt umber and
cobalt blue

Alizarin crimson,
cobalt blue and
raw sienna

Raw sienna,
cobalt blue and
burnt umber

The underpainting is done wet-on-wet. While still moist, drop in other colors, such as mauve. A good way to create texture is to use the flat side of a brush. When the painting is dry, take the flat brush with a small amount of paint and drag it lightly over the paper's surface. If you find that the painting needs even more texture, after the paint has dried, spatter it with an old toothbrush.

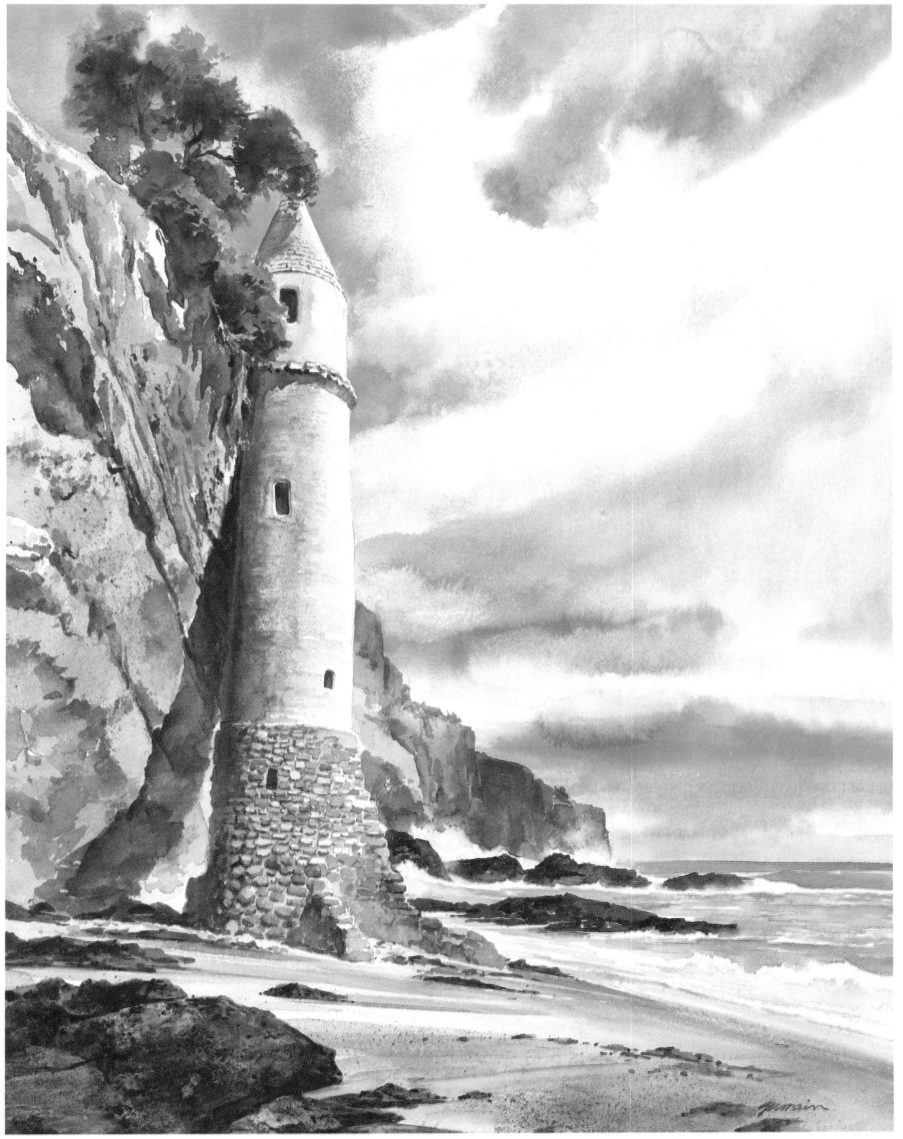

"Victoria Beach Staircase" Watercolor 18" x 25"

WINDSWEPT TREES

Notice the angle of the lean of the trees — they all lean the same way. Change colors as you go and make various sizes of limbs. Make thin and broad strokes. To create texture in the trees and the road, use blotting and spattering techniques.

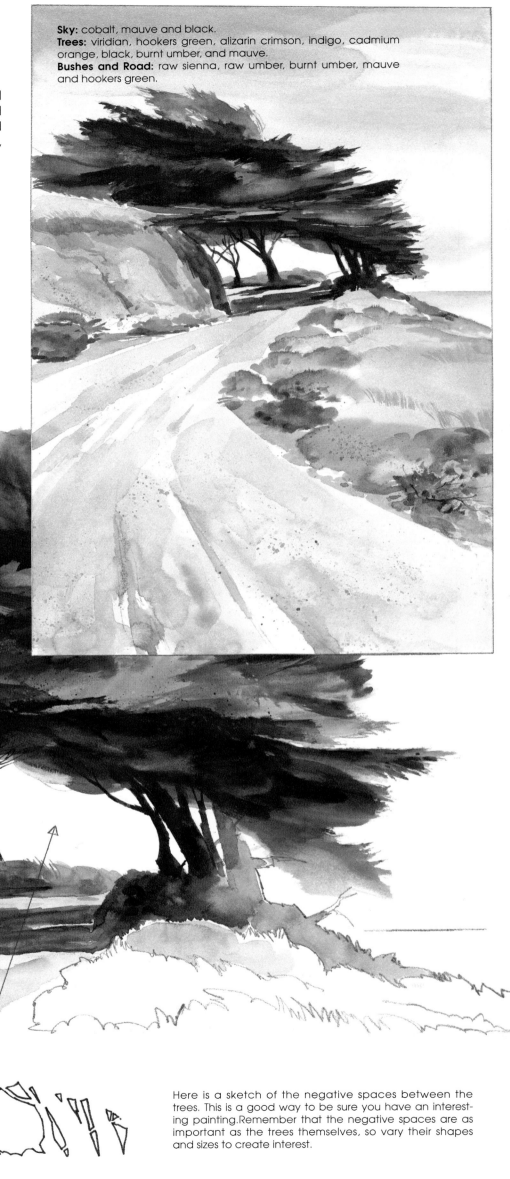

Sky: cobalt, mauve and black.
Trees: viridian, hookers green, alizarin crimson, indigo, cadmium orange, black, burnt umber, and mauve.
Bushes and Road: raw sienna, raw umber, burnt umber, mauve and hookers green.

Here is a sketch of the negative spaces between the trees. This is a good way to be sure you have an interesting painting. Remember that the negative spaces are as important as the trees themselves, so vary their shapes and sizes to create interest.

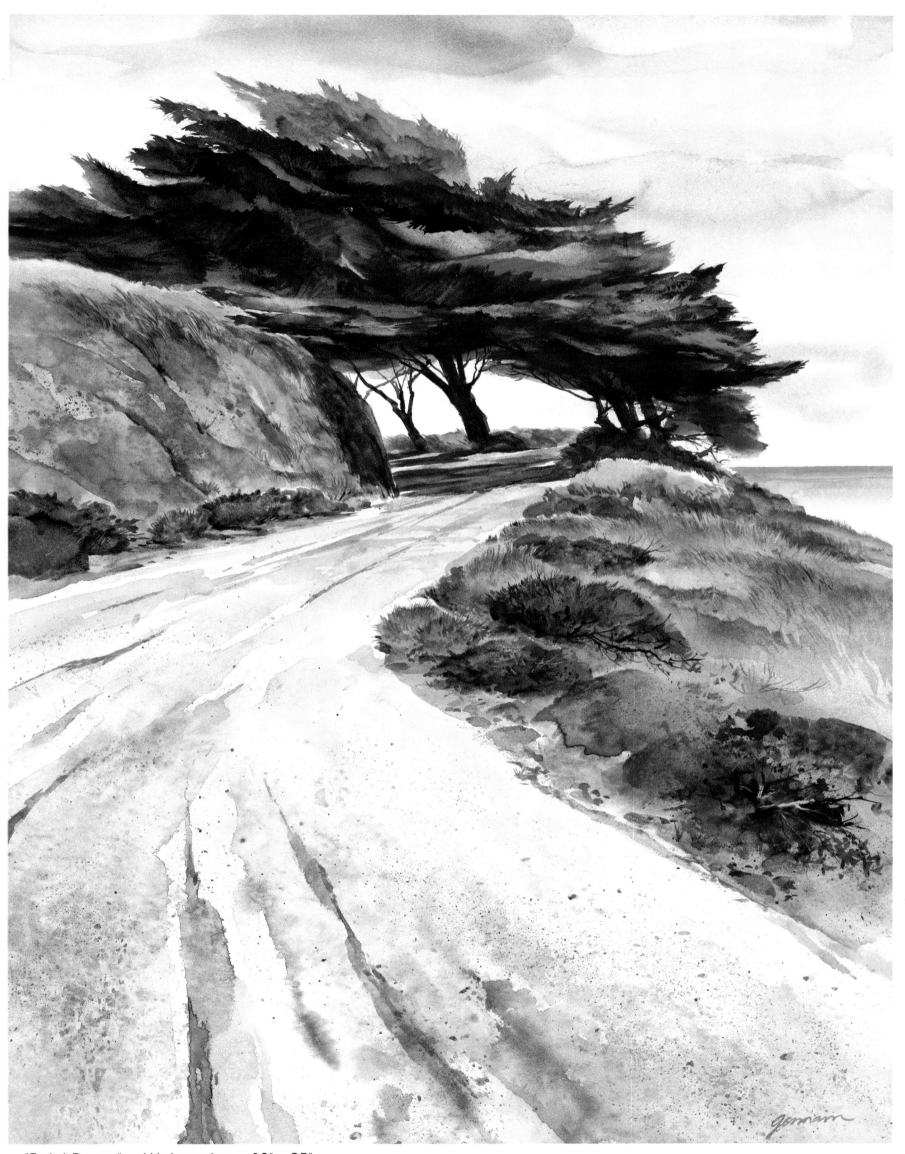

"Point Reyes" Watercolor 18" x 25"

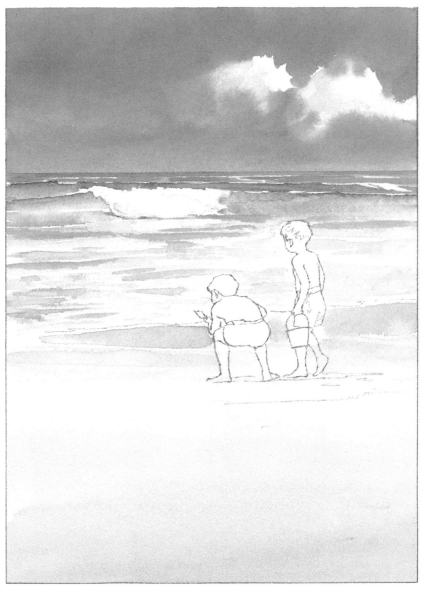

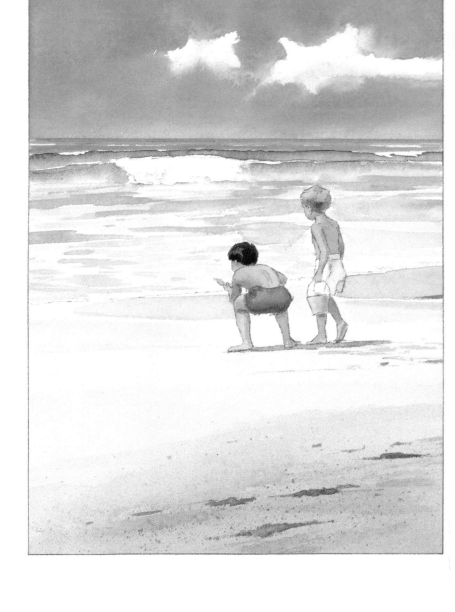

With a warm, bright sun like this you will have cool shadows (the figures are a good example). To create depth, the colors range from cool and pale in the distance to warm and dark in the foreground. Notice that the foreground has the only texturing, plus footprints and seaweed for contrast and interest.

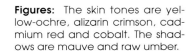

Figures: The skin tones are yellow-ochre, alizarin crimson, cadmium red and cobalt. The shadows are mauve and raw umber.

Paint the sand using horizontal strokes. Begin with thin paint, then make it darker as you come forward. To create texture: spatter, flick, blot with wax paper, foil, paper towel, scrape, erase, etc. The possibilities are almost endless. For this example, I used tracing paper to blot (this is exceptionally effective on smooth papers).

Blot

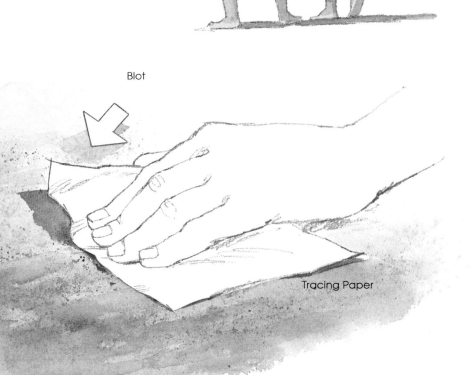

Tracing Paper

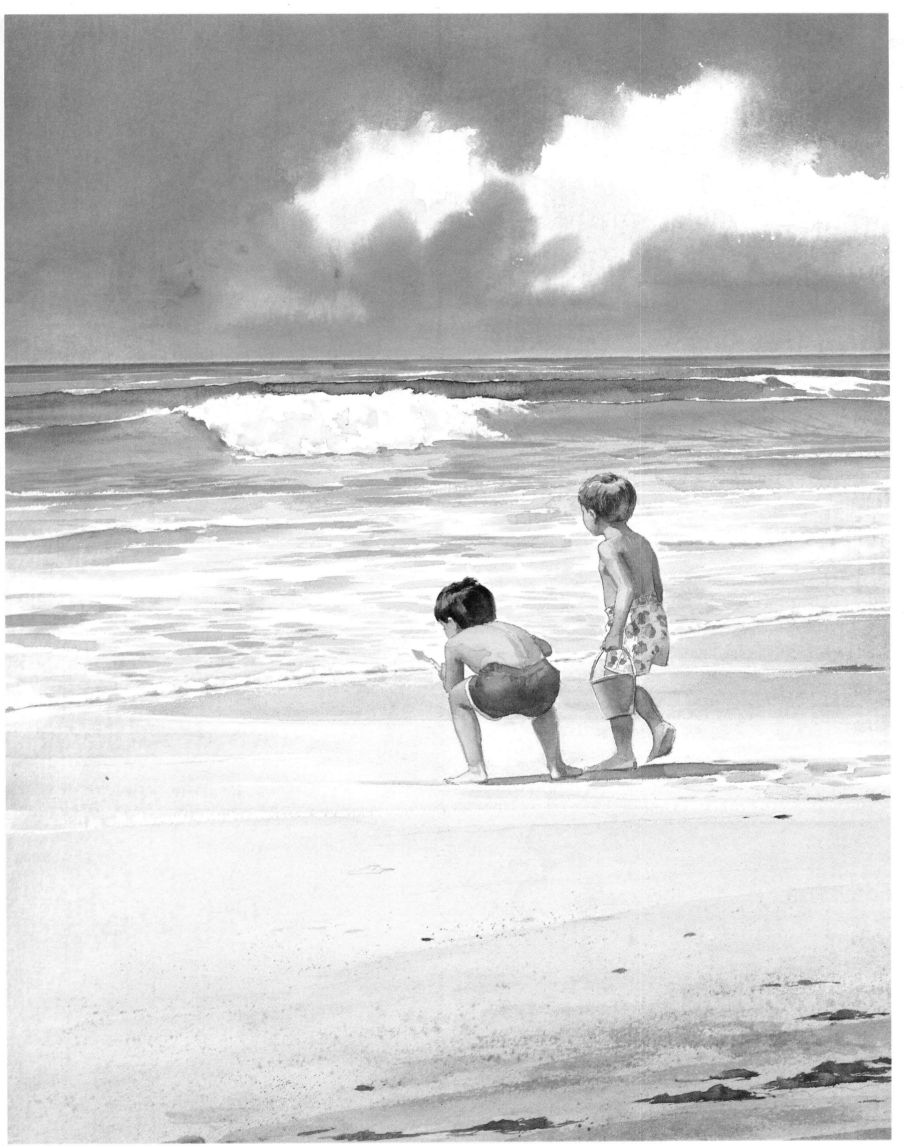

"A Day At The Beach" Watercolor 18" x 25"

"Stinson Beach" Watercolor 18" x 24"

Paint the sky, wet-into-wet, using cobalt and cerulean blues.

Use a straight edge for the water. Cobalt waves, then cobalt and ultramarine.

The figures are added last, mostly in silhouette.

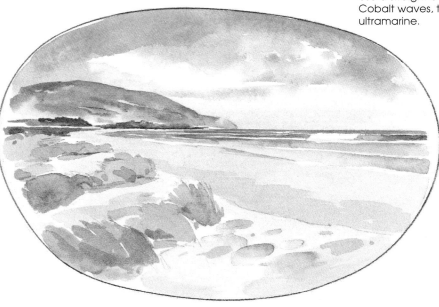

The grasses are cadmium yellow, and cobalt and cerulean blues painted wet-into-wet. The shadows are mauve.

Stroke in the sand as shown on pages 10 and 24. Use raw umber and burnt umber.

Detail grasses (see page 10).

Add darker colors on hills and grasses. Add shadows. Spatter for sand detail and add footprints.

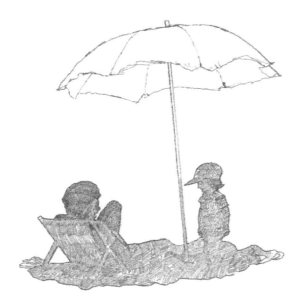

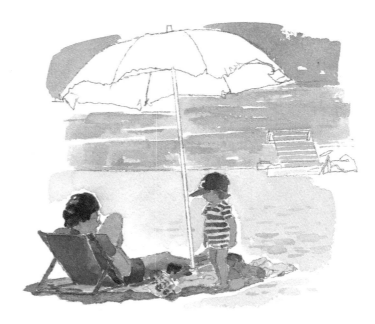

For good design, figures should "read" as silhouettes.

Use cobalt blue for the sky; cobalt, viridian and yellow for the water; raw umber and burnt umber for the sand; alizarin crimson, yellow ochre, cadmium red and viridian for the skin color; and mauve and raw umber for the shadows.

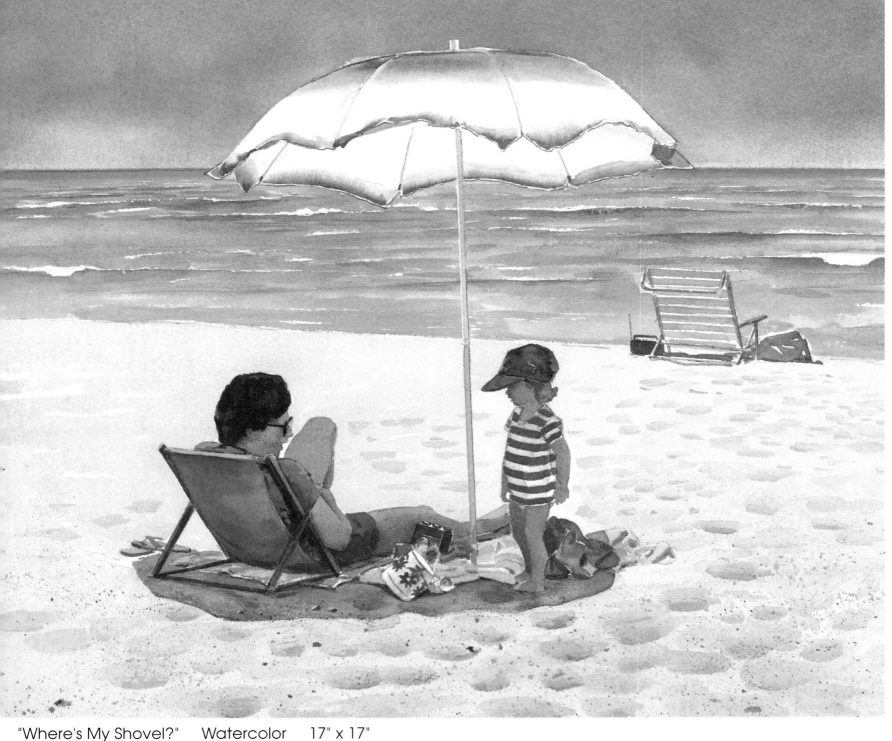

"Where's My Shovel?" Watercolor 17" x 17"

PAINTING A BEACH COMMUNITY

Most beach towns have similar qualities. They are frequently "bleached" by the sun and weathered by salt and wind. They usually have very little vegetation except for the hardiest grasses and plants, and they always have great charm and character.

To capture the feeling of the weather-beaten buildings, change colors and values as you move across the surface. Add texture. Remember — BOREDOM IS DEADLY!

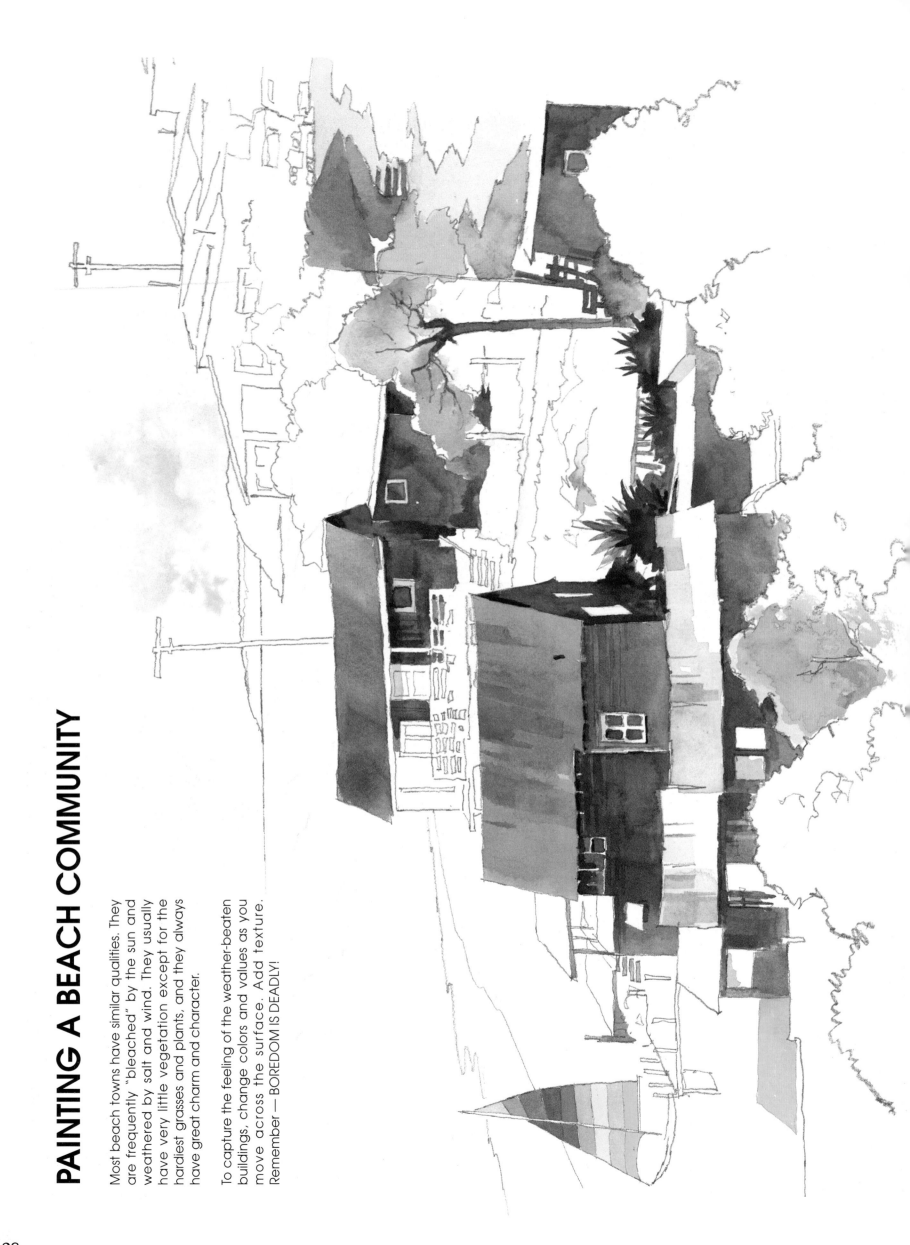

28

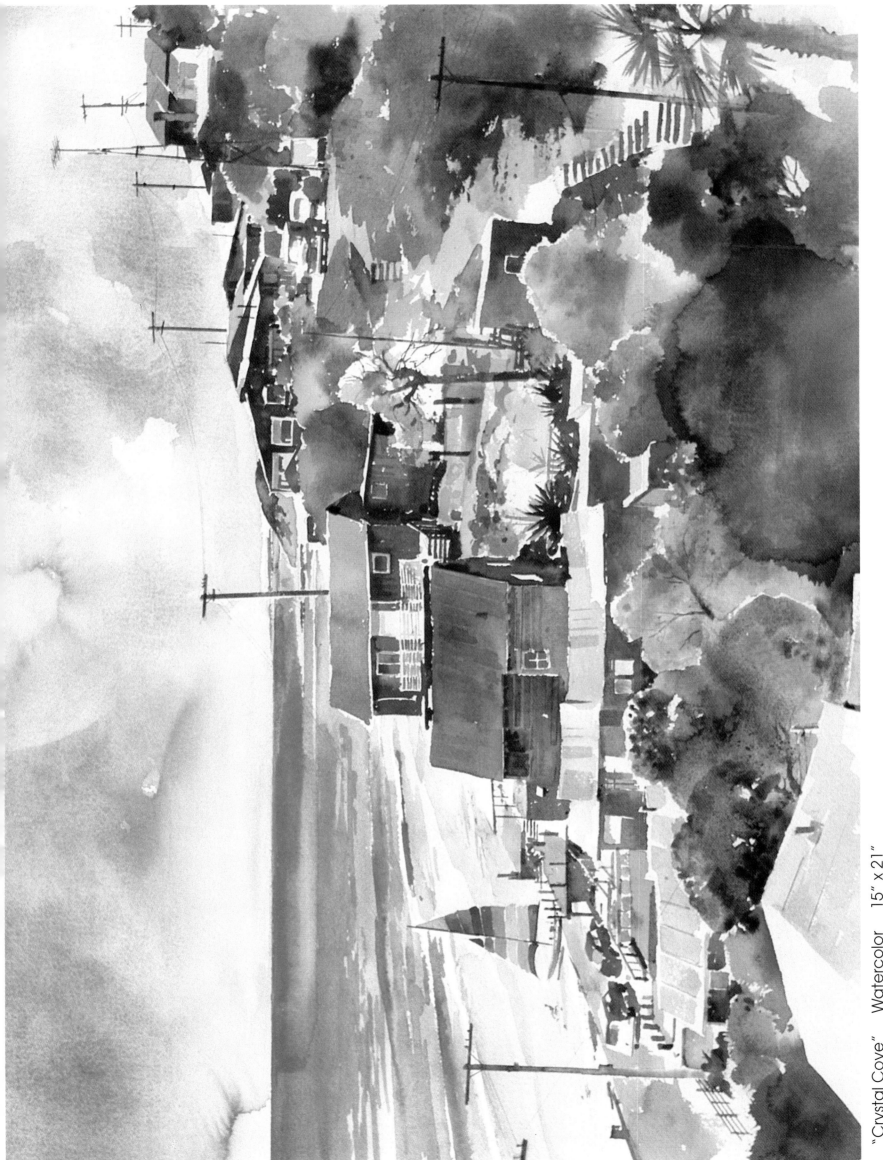

"Crystal Cove" Watercolor 15" x 21"

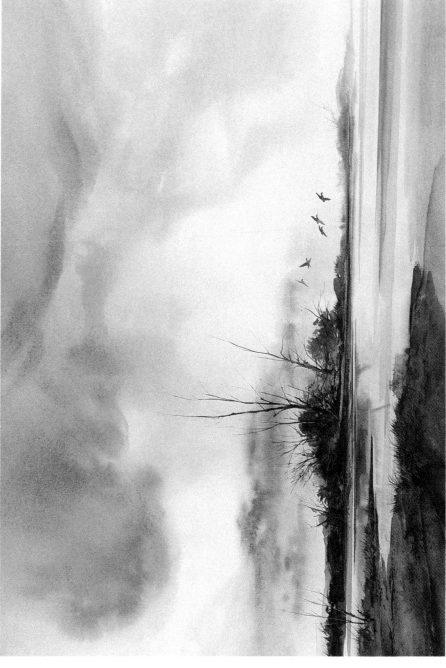

"Wetland" Watercolor 17" x 28"

"Wetland," "Tidal Flats," and "Main Beach" contain many of the techniques I have demonstrated in this book.

"Wetland" is a good example of wet-into-wet (see pages 4 and 5) with horizontal dry-brush stroking to create grass, brush, or tree branches (see page 10). This painting has a limited palette which makes it easier to control.

"Tidal Flats" has boat reflections plus the horizontal stroke to create a feeling of water. The sky was done wet-into-wet with blotting. The foreground foliage is also wet-into-wet with upward strokes to simulate grass and brush.

"Main Beach" shows the change of colors in the sky, foliage and beach (see pages 23 and 29). When painting the people, sand, and water (see pages 24 and 25), be sure to remember the cast shadows, and the footprints in the sand.

I hope this book has been of help to you. Happy painting!

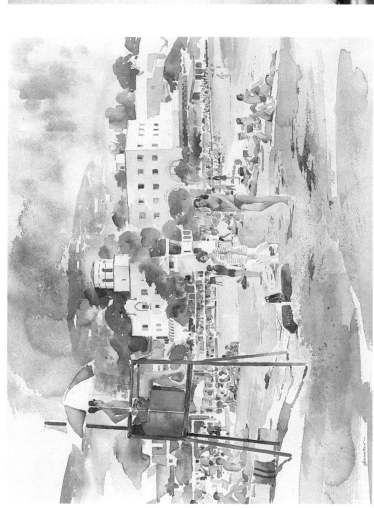

"Main Beach" Watercolor 17" x 23"

"Tidal Flats" Watercolor 28" x 37"

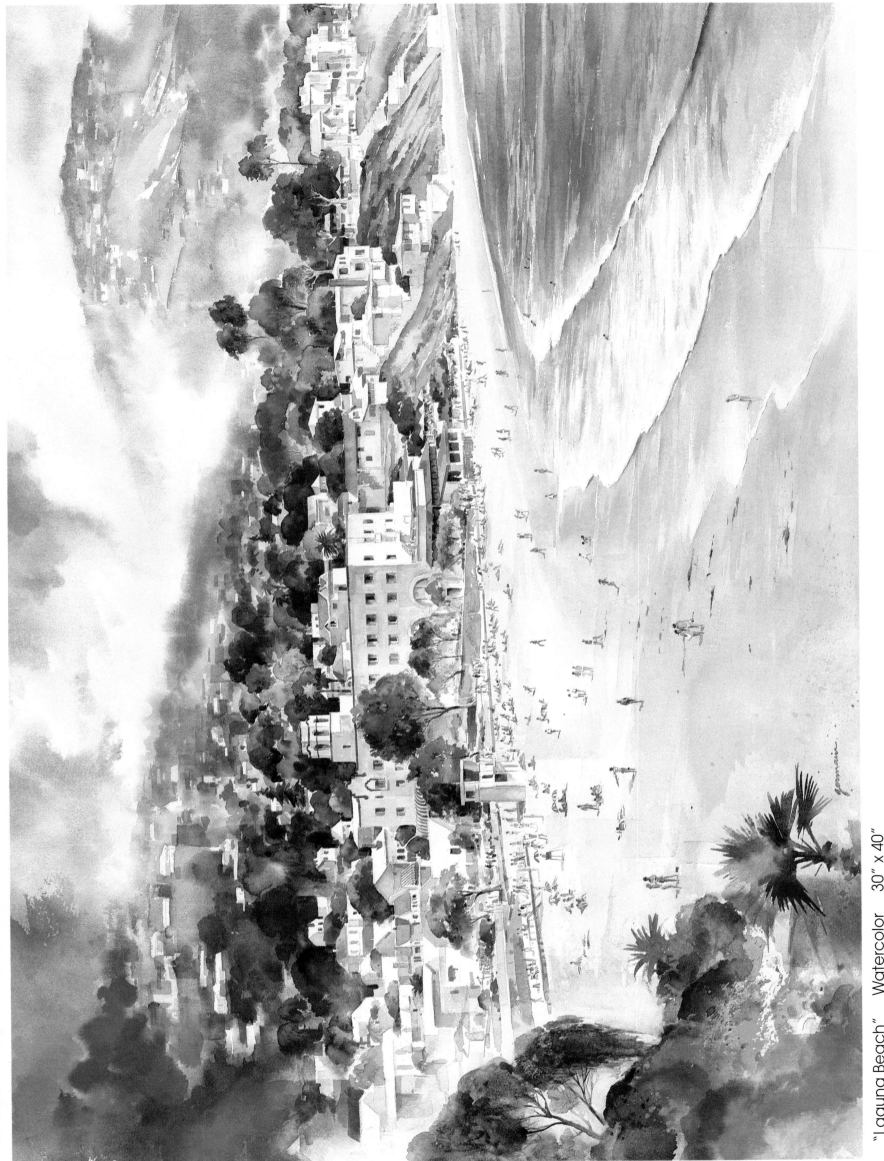

"Laguna Beach" Watercolor 30" x 40"

More Ways to Learn

Collector's Series

CS01 CS03 CS02

Collector's Series books are excellent additions to any library, offering a comprehensive selection of projects drawn from the most popular titles in our How to Draw and Paint series. These books take the fundamentals of a particular medium, then further explore the subjects, styles, and techniques of featured artists.

CS01, CS02, CS04: Paperback, 144 pages, 9" x 12"
CS03: Paperback, 224 pages, 10-1/4" x 9"

Artist's Library

AL26 AL04 AL02

The **Artist's Library** series offers both beginning and advanced artists many opportunities to expand their creativity, conquer technical obstacles, and explore new media. You'll find in-depth, thorough information on each subject or art technique featured in the book. Each book is written and illustrated by a well-known artist who is qualified to help take eager learners to a new level of expertise.

Paperback, 64 pages, 6-1/2" x 9-1/2"

How to Draw and Paint

HT130 HT242 HT26

HT222 HT

HT2

The **How to Draw and Paint** series includes books on every subject and medium to meet any artist's needs. These books provide clear step-by-step instructions, beautiful drawings and paintings, and helpful tips to teach aspiring artists the foundations of the art.

This series has seven collections—Animals, Still Lifes, Portraits & Figures, Seascapes, Landscapes, Cartoons, and Special Subjects. Each title has been authored and illustrated by well-known artists who have volumes of professional expertise to share.

Paperback, 32 pages, 10-1/4" x 13-3/4"

Walter Foster products are available at art and craft stores everywhere. Write or call for a FREE catalog that includes all of Walter Foster's titles.

Walter Foster™

Walter Foster Publishing, Inc. • 23062 La Cadena Drive • Laguna Hills, CA 92653 • (800) 426-00

32